如何練好
太極八法五步

How to practice the "Eight
Methods and Five Stances" of Taiji

《國際武術大講堂系列教學》
編委會名單

名 譽 主 任：冷述仁

名譽副主任：桂貴英　陳炳麟

主　　　任：蕭苑生

副　主　任：趙海鑫　張梅瑛

主　　　編：冷先鋒

副　主　編：鄧敏佳　鄧建東　陳裕平　冷修寧
　　　　　　冷雪峰　冷清鋒　冷曉峰　冷奔

編　　　委：劉玲莉　張貴珍　黃慧娟(印度尼西亞)
　　　　　　陳興緒　李美瑶　張念斯　鄧耀榮　葉英
　　　　　　葉旺萍　翁摩西　葉錫文　王振名(台灣)

《如何練好·太極八法五步》

主　　　編：鄧敏佳

副　主　編：馮永興　曹穀香

編　　　委：吳志強　周煥珍　冷余　鄧金超
　　　　　　冷飛鴻　向燕　陳雄飛　陳世紅
　　　　　　朱新文　崔順儀　杜知江　陳靈
　　　　　　胡振華　姜彩玲　李妙專　苗冬梅
　　　　　　葉惠娟　鄧月雲　李静芳　歐陽美光
　　　　　　何玉清　Joan（澳大利亞）　李國光
　　　　　　甘鳳群　吳佩芳　黎湄湄　黃鈺雯
　　　　　　黃麗兒　巫玉玲　楊素秋　鄭安娜
　　　　　　黃碧玉　賴天祈　戴裕强　何淑貞
　　　　　　黃綠英　葉梅珍　李曉峰

翻　　　譯：Philip Reeves（英國）　金子樺（香港）
　　　　　　Allen（加拿大）

序言

"太極"之名源于《易經》："易有太極，是生兩儀，兩儀生四象，四象生八卦......"。太極拳結合易學的陰陽五行之變化、中醫學的經絡學説以及導引、吐納術，并綜合百家拳術之長而創立的。太極拳"以柔克剛、以静制動、借力打力、四兩撥千斤"的拳理，在中華武林獨樹一幟。太極拳包含了中國傳統哲學、養生學、醫學、武學、美學等衆多學科，不僅是中國功夫之集大成者，更是中國幾千年燦爛文化的結晶，是東方文明的代表。

對太極拳而言，只有總結歸納出一整套易于理解、便于操作、不出偏差、收效快的練習方法，才能指導更多的學習者掌握太極要領，逐步登堂入室。基于此，本人結合三十多年的學武經歷，吸取在學習和教學中的各種理論和技術經驗，并聽取中國武術協會主管部門領導、體育院校教授、傳統名家、甚至廣大武術愛好者的寶貴意見，爲了弘揚和傳承中華武學，從而創編《國際武術大講堂系列叢書》，而本書《如何練好·太極八法五步》是其中最基本最重要的内容，并由陳式太極拳第十二代正宗傳人、太極拳名家鄧敏佳老師親身示範、教授，數百幀全彩圖片詳盡展示技術細節，全程要點提示指導，對古老的傳統太極理論既完整繼承而又推陳出新，針對太極拳的内涵，抓住太極拳的本質，提出了一整套系統的修煉方法，能讓太極拳學習者快速體悟太極拳真諦，達到身心雙修的無我境界！

注：此書中"Taiji"和"TaiChi"爲同一意思。

在本書創編過程之中，適逢國家體育總局等14部委聯合印發《武術產業發展規劃（2019-2025年）》，規劃中提出要堅持傳承、弘揚中華傳統武術文化，講好武術文化故事，體現中國武術精神，展示中國武術形象，我們也爲之振奮和深感肩負的歷史使命和傳承重任。因此編寫本套系列叢書，也是牢固樹立新發展理念，以弘揚傳統武術文化、滿足群衆武術健身需求爲出發點，實現中華優秀傳統文化的創造性轉化和創新性發展。

冷先鋒

2020年5月寫于香港

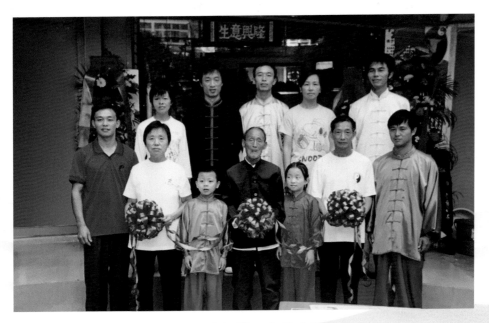

四代同堂 · 太極世家

Preface

The name "Taiji" has its origin in the "I Ching" (Book of Changes): "Changes produces Taiji. Taiji generates the two polarities (Yin-yang). The two polarities generate the four images (Sixiang). The four images generate the eight trigrams (Bagua)." The expansion was believed to continue to infinity (an undefined state). Taijiquan combines yin-yang balance and the variety of the five elements, the meridional theory of Chinese medicine as well as breathing techniques and integrated in many styles of Chinese wushu. Taijiquan "uses softness to conquer strength, uses stillness to control motion", "exploits power to beat power, uses an ounce to outbalance a ton", which makes taijiquan unique amongst Chinese martial arts.

Taijiquan apart being a school of wushu, also consist of Chinese traditional philosophy, medicine, nutrition and beauty of forms. It is not only the quintessence of Chinese Kungfu, but also the crystallization of China's splendid culture over many millennia and a representation of Eastern civilization.

For the promotion of and to inherit Chinese wushu, a good book is obviously needed. It is necessary to summaries a set of easy-to-understand, easy-to-practice routines for the learners so that they can be guided properly and gradually achieve the skills of taijiquan. Based on this, together with my thirty years' experience of teaching and practicing Taijiquan, and also the precious opinions from the Chinese Wushu Association, professors of sports colleges, traditional masters and many martial arts enthusiasts, I have created the "International Wushu Lecture Series". The book "Taiji

Thirteen, Eight Methods and Five Steps" provides the most basic and important content of the series. It is demonstrated by the 12th generation direct descendant in the lineage of Chen Style Taijiquan, the famous taijiquan Master Deng Minjia, illustrated with hundreds of full-colour pictures showing the technical details, with full explanations, so that the ancient tradition of taiji theory is passed on in full: it presents a systematic set of methods focused on the essentials to grasp the essence of taiji Plan, which enables taijiquan students quickly to realize the true meaning of taijiquan and so achieve an improved state of body and mind.

This book has been developed in line with the "Wushu Industry Development Plan, 2019-2025", jointly issued by the 14 ministries and commissions including the State Sports General Administration, wherein it is proposed to pass on and develop Chinese martial arts culture, tell the story of martial arts culture, reflect the spirit of Chinese martial arts, and display the image of Chinese martial arts. We are also inspired by and deeply aware of the heavy responsibility of this historic mission, to promote traditional martial arts culture, to meet the needs of the masses for a starting point and foundation in martial arts fitness, and to realize the creative transformation and innovative development of China's excellent traditional culture.

<div align="right">

Xianfeng Leng

Written in Hong Kong, August 2019

</div>

Note: 'Taiji' and 'TaiChi' are the same meaning in this book.

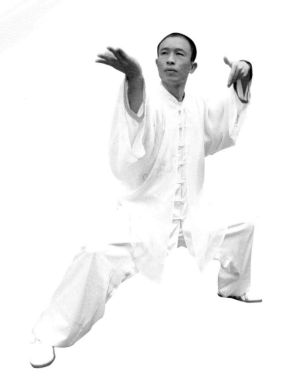

冷先鋒簡介
Profile of Master Xianfeng Leng

　　江西修水人，香港世界武術大賽發起人，當代太極拳名家、全國武術太極拳冠軍、香港全港公開太極拳錦標賽冠軍、香港優秀人才，現代體育經紀人，自幼習武，師從太極拳發源地中國河南省陳家溝第十代正宗傳人、國家非物質文化遺産傳承人、國際太極拳大師陳世通大師，以及中國國家武術隊總教練、太極王子、世界太極拳冠軍王二平大師。

　　中國武術段位六段、國家武術套路、散打裁判員、高級教練員，國家武術段位指導員、考評員，擅長陳式、楊式、吳式、武式、孫式太極拳和太極劍、太極推手等。在參加國際、國內大型的武術比賽中獲得金牌三十多枚，其學生弟子也在各項比賽中獲得金牌四百多枚，弟子遍及世界各地。

二零零八年被香港特區政府作爲"香港優秀人才"引進香港，事迹已編入《中國太極名人詞典》、《精武百杰》、《深圳名人錄》、《香港優秀人才》；《深圳特區報》、《東方日報》、《都市日報》、《頭條日報》、《文匯報》、《香港01》、《星島日報》、《印尼千島日報》、《國際日報》、《SOUTH METRO》、《明報周刊》、《星洲日報》、《馬來西亞大馬日報》等多次報道；《中央電視台》、《深圳電視台》、《廣東電視台》、《香港無綫TVB翡翠台》、《日本電視台》、《香港電台》、《香港商台》《香港新城財經台》多家媒體電視爭相報道，并被美國、英國、新加坡、馬來西亞、澳大利亞、日本、印度尼西亞等國際幾十家團體機構聘爲榮譽顧問、總教練。

　　冷先鋒老師出版發行了一系列傳統和競賽套路中英文DVD教學片，最新《八法五步》、《健康太極十三勢》、《陳式太極拳》、《規定長拳》、《五步拳》、《樂齡養生太極拳》等太極拳中英文教材書，長期從事專業的武術太極拳教學，旨在推廣中國傳統武術文化，讓武術太極拳在全世界發揚光大。

　　冷先鋒老師本着"天下武林一家親"的理念，以弘揚中華優秀文化爲宗旨，讓中國太極拳成爲世界體育運動爲願景，以向世界傳播中國傳統文化爲使命，搭建一個集文化、健康與愛爲一體的世界武術合作共贏平臺，以平台模式運營，走產融結合模式，創太極文化產業標杆爲使命，讓世界各國武術組織共同積極參與，達到在傳承中創新、在創新中共享、在共享中發揚。爲此，冷先鋒老師于2018年發起舉辦香港世界武術大賽，至今已成功舉辦兩屆，盛況空前。

Master Leng is the promoter of the Hong Kong World Martial Arts Competition a renowned contemporary master of taijiuan, National Martial Arts Tijiuan Champion, Champion of Hong Kong Tajiquan Open Championship, Outstanding talents in Hong-Kong And Modern sports brokers.Master Leng has been a student of martial arts since childood, he is a 11th generation direct descendant in the lineage of Chenjiagou-the home of taijiquan, and inheritor and transmitter of Intangible National Cultural Heritage. Master Leng is both the student of International Taiji Master Chen Shitong and Taiji Prince, Master Wang Erping, head coach of the Chinese National Wushu Team and World Taijiquan Champion. Master Leng, level six in the Chinese WushuDuanwei System, is a referee, senior coach and examiner at national level. Master Leng is accomplished in Chen, Yang, Sun, Wu and Wu styles of taijiquan, Taiji sword and push-hands techniques. Master Leng has participated in a series ofintemational and prominent domestic taijiquan, taiji sword and push-hand competitions.Master Leng has won more than 30 championships and gold medals, and his students have won more than 400 gold medals and other awards in various team and individual competitions. Master Leng has followers throughout the world.

In 2008, Master Leng moved to Hong Kong through the "Quality Migrant Admission Scheme". His deeds have been recorded in various publications suchas Chinese Taiji Celebrity Dictionary", 100 heroes of elite Chinese Martial Arts", Shenzhen Who's Who ","Hong Kong Outstanding Talents " , etc. He was interviewed by local and foreign newspapers and magazines such as , "Shenzhen Special Zone Daily," "Hong Kong's Oriental Daily" ,"Metropolis Daily", "Headline Daily", "Wenhui Daily" , Hong Kong01", "Sing Tao Daily", "Indonesian Thousand Island Daily", "International Daily , "South Metro ,"Ming Pao weekly",etc. Master Leng also invited to appear in radio and TV programs hosted by "TV", "ShenzhenTVStation", "Guangdong TV Station", "Hong Kong TVB Jade Channel","Radio Hong Kong" , "Hong Kong Commer-

cial Radio", "Hong Kong Metro Radio .Finance and Economics Channel," and so on. Master Leng has been retained as an honorary consultant and head coach by dozens of international organizations in the United States, Britain, Singapore, Malaysia,Australia, Japan and Indonesia.

To facilitate teaching and spreading of Taiji culture, Master Leng has produceda number of DVDs in various routines of Taijiquan and Martial Arts, The latest "Eight Method Five Steps "," Health Tai Chi 13 "," Chen Style Taijiquan" , " Chang Quan" and other Chinese and English Taijiquan textbooks, both in English and Chinese. Master Leng has long been engaged as a professional teacher of taijiquan.Master Leng has more than a dozen taijiquan equipment shops, and an advancedtaiji health establishment, and aims to create a top-quality Leng Xianfeng" brandand expand it throughout the world.

Master Leng teaches in the spirit of a world martial arts family" , with the goalof "spreading Chinese traditional culture, and achieving a world-wide family of taijiquan." He promotes China's outstanding culture with the vision of making taijiquan apopular sport throughout the world" . As such, Master Leng has set out to build aninternational business platform that promotes culture, health and love across theworld of martial arts practitioners to achieve mutual cooperation and integratedproduction and so set a benchmark for the taiji culture industry. Let martial artsorganizations throughout the world participate actively, achieve innovation inheritage, share in nnovation, and promote in sharing! To this end, Master Lenginitiated the Hong Kong World Martial Arts Competition in 2018 and has so farsuccessfully held two events.

鄧敏佳簡介
Profile of Master Minjia Deng

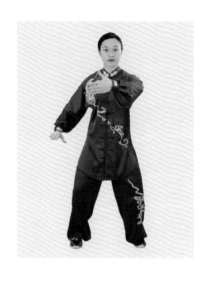

鄧敏佳老師，1983年出生于廣東梅州，畢業于廣州大學，自幼習武，師從當代太極拳名家、陳氏太極第十一代正宗傳人冷先鋒老師，是陳氏太極拳正宗傳人，香港全港公開太極拳錦標賽冠軍，50kg推手冠軍，目前擔任香港國際武術總會副主席和總教練，并在多間校園、高級會所及政府機構中任教，經常參與一些社會公益推廣活動。

鄧敏佳老師從2006年以來開始在香港和中國內地開設培訓班傳授太極拳，所教學生達數千人，其學生在中國香港和各省市、國家級武術比賽中，纍計獲得獎牌上百枚。鄧敏佳老師曾應邀赴美國、英國、日本、澳大利亞、印尼、新加坡、台灣等國家和地區進行交流、講學及裁判工作。多年的教學鑽研，對太極拳頗有造詣，爲國內外培養了一大批優秀的太極拳教練員及運動員，爲推廣武術太極拳運動的普及、健身及競賽做了大量工作，爲把太極拳運動推向世界作出很大的貢獻。

同時，鄧敏佳老師在太極拳傳授與學習中，以女性獨特的視角，把太極陰陽平衡、以柔克剛的拳理與女性自強自立的品格相結合，傳播傳統武術運動和時尚運動相融合的理念，倡導更多女性參與練習太極拳，讓更多的女性愛上太極拳運動，強身健體、陶冶情操。

Master Deng Minjia was born in Meizhou Guangdong province of China in 1983. She is a graduate of the University of Guangzhou. She has practiced taijiquan from a young age under the tutelage of the famous, living taiji Master Leng Xianfeng, who is the 11th generation descendent in the lineage of Chen-style taijiquan.

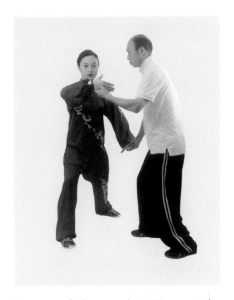

Master Deng is a direct descendent in the lineage of Chen-style taijiquan. She is the champion of Hong Kong Taijiquan Open Championship as well as 50kg-class push-hands competition. Currently she serves as vice-chairperson of the Hong Kong International Wushu Association. Master Deng also serves on a number of social welfare organisations.

Since 2006, Master Deng has taught classes across Hong Kong and Shenzhen in both fist and sword styles of taiji. Her students amount to thousands, winning hundreds of medals in competitions in Hong Kong and at provincial and national level across China.

Master Deng has been invited to Japan, Australia, Indonesia, Singapore, Taiwan and other countries and regions for exchange visits, to give lectures and as a referee. Master Deng's contribution to Taiji attributes in her high quality Taiji teaching which results in her achievement in training numerous high quality Taiji athletes and instructors, and in her efforts in promoting Taijiquan to the world. Being a female Taijiquan practitioner enables her in a position to apply Yin/Yang theory in a more convincing manner which is especially helpful to her female students. This encourages them to cultivate zest in Taijiquan, hence achieving overall physical and mental health.

 # 冷先鋒太極 (武術) 館

中華武術

火熱招生中......

地址:深圳市羅湖區紅嶺中路1048號東方商業廣場一樓、三樓

電話:13143449091　　13352912626

【名家薈萃】

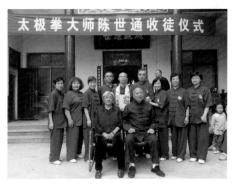

陳世通收徒儀式

王二平老師

趙海鑫、張梅瑛老師

武打明星梁小龍老師

王西安老師

陳正雷老師

余功保老師

林秋萍老師

門惠豐老師

張山老師

高佳敏老師

蘇韌峰老師

李德印教授

錢源澤老師

張志俊老師

曾乃梁老師

郭良老師

陳照森老師

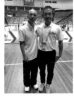

張龍老師

陳軍團老師

【名家薈萃】

劉敬儒老師

白文祥老師

張大勇老師

陳小旺老師

李俊峰老師

戈春艷老師

李德印教授

馬春喜、劉善民老師

丁杰老師

付清泉老師

馬虹老師

李文欽老師

朱天才老師

李傑主席

陳道雲老師

馮秀芳老師

陳思坦老師

趙長軍老師

【獲獎榮譽】

【電視采訪】

【電視采訪】

【電臺訪問】

【合作加盟】

【媒體報道】

【培訓瞬間】

百城千萬人太極拳展演活動　　　　　　　雅加達培訓

汕頭培訓　　　　王二平深圳培訓　　　　師父70大壽

香港公開大學培訓　　印度尼西亞培訓　　　松崗培訓　　　香港荃灣培訓

王二平深圳培訓　　　陳軍團香港講學　　　印尼泗水培訓

油天培訓　　　印尼扇培訓　　　七星灣培訓　　　陳軍團香港講學培訓

油天培訓　　　美國學生　　　馬春喜香港培訓班

【賽事舉辦】

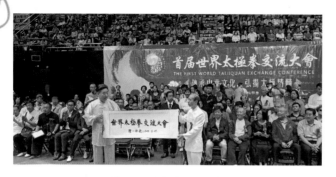

首屆世界太極拳交流大會

第二屆"太極羊杯"香港世界武術大賽

第二屆"太極羊杯"大賽

日本德島國際太極拳交流大會

首屆世界太極拳交流大會

馬來西亞武術大賽

東莞擂臺表演賽

首屆永城市太極拳邀請賽

首屆永城市太極拳邀請賽

2018首屆香港太極錦標賽

2019首屆永城市太極拳邀請賽

目　　録

DIRECTORY

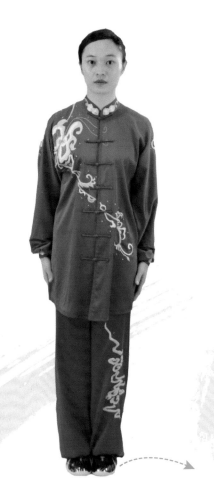

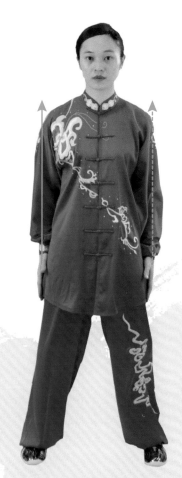

1-1

1-2

 第一式:起勢

[動作]:自然站立,兩臂松垂,左腳向左橫開一步,與肩同寬,兩臂向前、向上平舉,與肩同高,屈膝下按,按至腹前。目視前下方。

[要點]:心靜體松,立身中正。

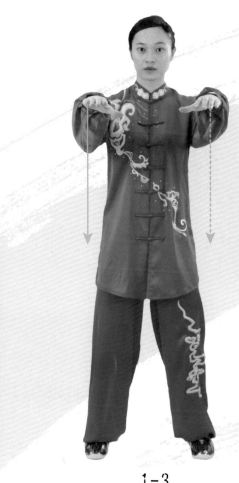

1-3

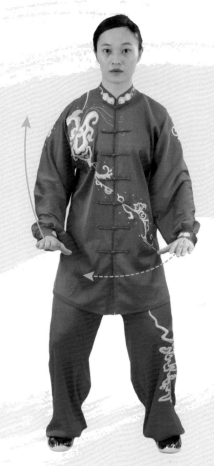

1-4

1.Starting form

[Action]: Stand naturally, arms loosely at the sides, move left foot one step to the left, shoulder width apart; raise arms forwards and upwards to shoulder level; bend knees while pressing downwards to the front of the abdomen. Look forwards and slightly downwards.

[Key Points]: Mind quiet, body relaxed and stand upright.

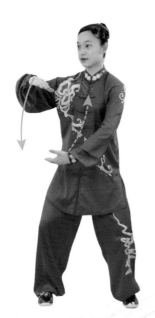
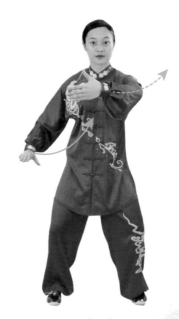

2-1 2-2

 第二式：左掤勢

[動作]:身體右轉,右手向上劃弧至右胸前,掌心向下,左手收至腹前,掌心向上,身體左轉,左臂向前掤出,與肩同高,右手下按至右胯旁,目視前方。

[要點]:掤勢力點在手臂外側,下按手與掤手形成對拉勁。

2.Left ward-off

[Action]: Turn body right; raise right hand in an arc to the right of the chest, palm down; bring left hand to the front of the abdomen, palm up; turn body left, lift left arm forwards and outwards up to shoulder level, press right hand down to the right hip; look forwards.

[Key Points]: The ward-off force point is on the outside of the arm; the hand pressing down and the arm warding-off are in tension with each other.

29

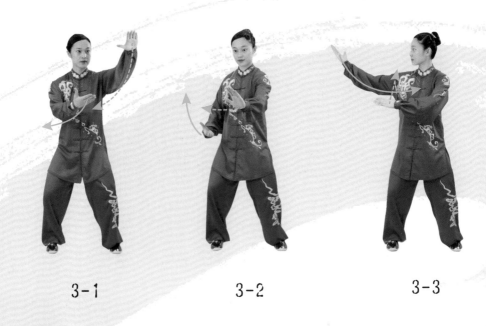

3-1 3-2 3-3

第三式:右捋勢

[動作]:身體微左轉,兩臂向前伸展,左掌心向下,右掌心向上,身體右轉,兩臂向右、向下捋帶,目視右手方向。

[要點]:捋勢意在兩掌,註意以腰帶臂。

3.Right rollback

[Action]: Turn body slightly left; extend arms forward, left palm down, right palm up; turn body right, draw both arms to the right and downwards; look in the direction of the right hand.

[Key Points]: The rollback force is expressed in the two palms. Note the waist leads the arms.

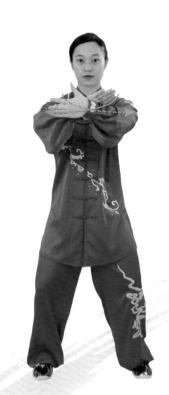

4-1

 第四式：左擠勢

[動作]:身體左轉,兩掌在胸前相搭,左掌在外,向前擠出,左掌心向內,右掌心向外,目視前方。

[要點]:擠勢力點在左手背,要有擠壓之勢。

4.Left push

[Action]:Turn body left; bring the two palms together in front of the chest, the left palm outermost; push forward with the left palm facing inward, the right palm facing outward; look forwards.

[Key Points]: The pushing force point is in the back of the left hand, there must be increasing pressure.

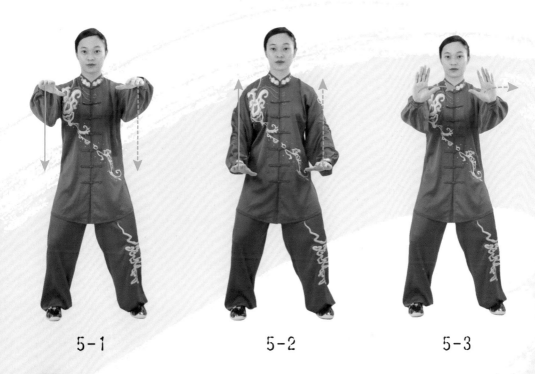

5-1 5-2 5-3

 # 第五式:雙按勢

[動作]:兩掌平抹分開,掌心向下,身體微右轉,兩掌回收、向下、再向前劃弧前推,力達掌根,目視前方。

[要點]:按勢意在腰背成弓形,含胸拔背。

5.Double hand press

[Action]: Spread the palms apart, palms down; turn body slightly right, cycle the palms backwards and downwards, then push in an arc forwards and upwards, push through the base of the palms; look forwards.

[Key Points]: The pressing force is expressed by arching the back with the chest drawn inwards.

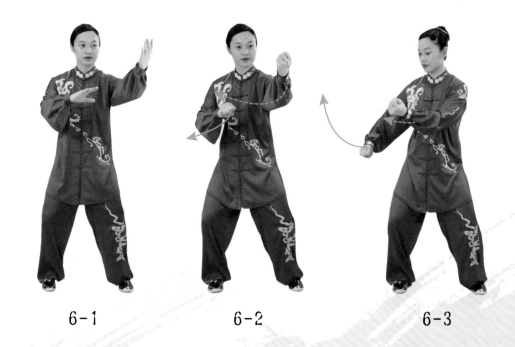

6-1 6-2 6-3

第六式：右採勢

[動作]:兩掌變拳,身體右轉,向右、向下採拉,右拳心向下,左拳心向上,目視右下方。

[要點]:採勢意在手指拿捏,隨腰轉動順勢下拉。

6.Right grab

[Action]: Palms become fists; turn body right; pull rightwards and downwards, right fist fingers down, left fist fingers up; look towards the lower right.

[Key Points]: The pulling force is expressed by gripping and pulling downwards while rotating the waist.

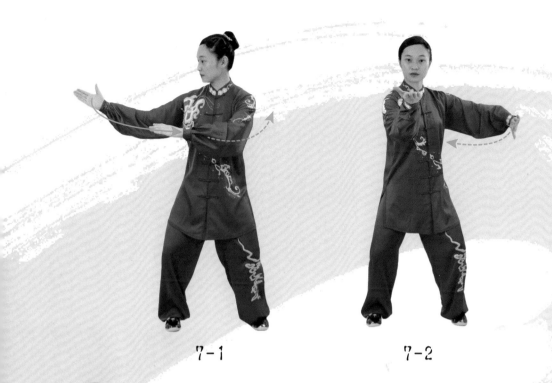

7-1 7-2

☯ 第七式:左捌勢

[動作]:身體左轉, 兩拳變掌, 向左橫捌, 右掌心向上, 左掌心向外, 目視前方。

[要點]:捌勢意在以腰帶臂, 橫向用力。

7.Left split

[Action]: Turn body left; fists become palms; rotate laterally leftwards, right palm upward, left palm outward; look forwards.

[Key Points]: The splitting force is expressed by exerting force laterally, the waist leads the arms.

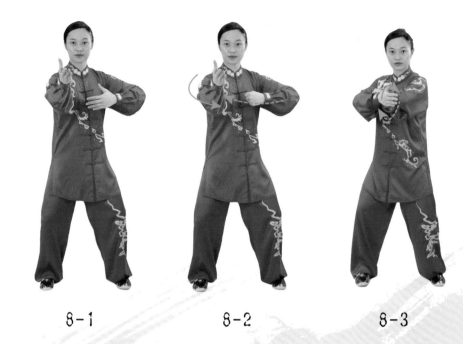

8-1 8-2 8-3

 第八式:左肘勢

[動作]:身體右轉, 左掌變拳, 拳眼向上, 屈臂向前以肘擊打, 右手附於左臂外側, 目視前方。

[要點]:肘勢意在以肘尖為力點攻擊, 先屈臂再發力。

8.Left elbow-strike

[Action]: Turn body right; left palm becomes fist; fist upright, bend arm and strike forward with elbow; place right hand to the outside of left arm; look forwards.

[Key Points]: The elbow-strike force is expressed through the tip of the elbow, first bending the arm and then releasing energy.

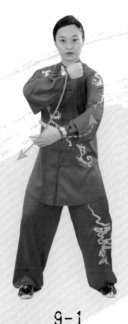

9-1 　　　　　　　　　9-2

 # 第九式：右靠勢

[動作]:身體左轉, 右掌變拳, 左拳變掌, 兩臂環繞, 右臂撐圓, 拳眼向內, 用右肩臂向前靠擊, 左掌收至右肩旁, 掌心向外, 目視前方。

[要點]:靠勢意在以肩臂為力點, 利用整個身體前移撞擊。

9.Right shoulder-strike

[Action]: Turn body left; right palm becomes fist, left fist becomes palm; cycle the two arms; arch and brace right arm, fist downwards and lateral; butt forwards with right shoulder and arm; bring left palm to right shoulder, palm facing outward; look forwards.

[Key Points]: The shoulder-strike force is expressed with the impact of the entire body through the shoulder and arm.

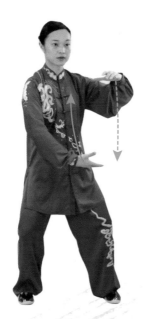

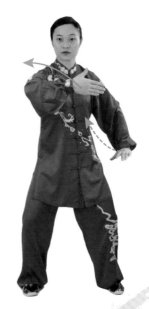

10-1　　　　　　10-2

 # 第十式:右掤勢

[動作]:身體左轉,兩掌相抱,掌心相對,右臂向前掤出,與肩同高,左手下按至左胯旁,目視前方。

[要點]:掤勢力點在手臂外側,下按手與掤手形成對拉勁。

10.Right ward-off

[Action]: Turn body left; the two palms embrace as if holding a ball, palms facing each other; turn body right, lift right arm forwards and outwards up to shoulder level, press left hand down to the left hip; look forwards.

[Key Points]: The ward-off force point is on the outside of the arm; the hand pressing down and the arm warding-off are in tension with each other.

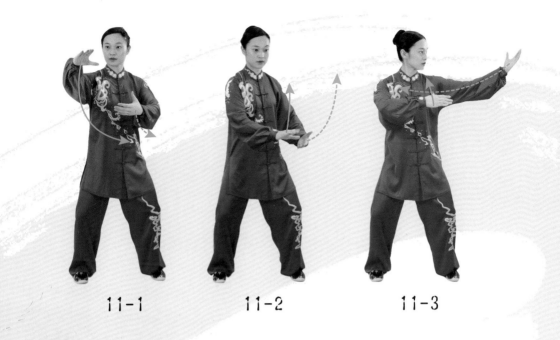

11-1　　　　11-2　　　　11-3

第十一式:左将勢

[動作]:身體微右轉,兩臂向前伸展,右掌心向下,左掌心向上,身體左轉,兩臂向左、向下将帶,目視左手方向。

[要點]:将勢意在兩掌,註意以腰帶臂。

11.Left rollback

[Action]: Turn body slightly right; extend arms forward, right palm down, left palm up; turn body left, draw both arms to the left and downwards; look in the direction of the left hand.

[Key Points]: The rollback force is expressed in the two palms. Note the waist leads the arms.

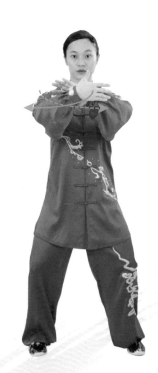

12-1

 第十二式：右擠勢

[動作]：身體右轉，兩掌在胸前相搭，右掌在外，向前擠出，左掌心向外，右掌心向內，目視前方。

[要點]：擠勢力點在右手背，要有擠壓之勢。

12.Right push

[Action]: Turn body left; bring the two palms together in front of the chest, the right palm outermost; push forward with the right palm facing inward, the left palm facing outward; look forwards.

[Key Points]: The pushing force point is in the back of the right hand, there must be increasing pressure.

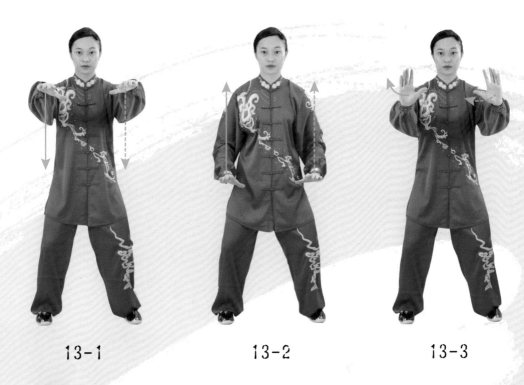

13-1　　　　　　　　13-2　　　　　　　　13-3

 # 第十三式:雙按勢

[動作]:兩掌平抹分開, 掌心向下, 身體微左轉, 兩掌
回收、向下、再向前劃弧前推, 力達掌根, 目視前方。

[要點]:按勢意在腰背成弓形, 含胸拔背。

13.Double hand press

[Action]: Spread the palms apart, palms down; turn body slightly left, cycle the palms backwards and downwards, then push in an arc forwards and upwards, push through the base of the palms; look forwards.

[Key Points]: The pressing force is expressed by arching the back with the chest drawn inwards.

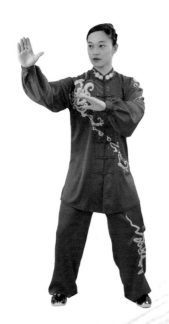

14-1　　　　　　　14-2　　　　　　　14-3

 第十四式:左採勢

[動作]:身體左轉, 兩掌變拳, 向左、向下採拉, 右拳心向上, 左拳心向下, 目視左下方。

[要點]:採勢意在手指拿捏, 隨腰轉動順勢下拉。

14.Left grab

[Action]: Turn body left; palms become fists; pull to the left and downwards, right fist fingers up, left fist fingers down; look towards the lower left.

[Key Points]: The pulling force is expressed by gripping and pulling downwards while rotating the waist.

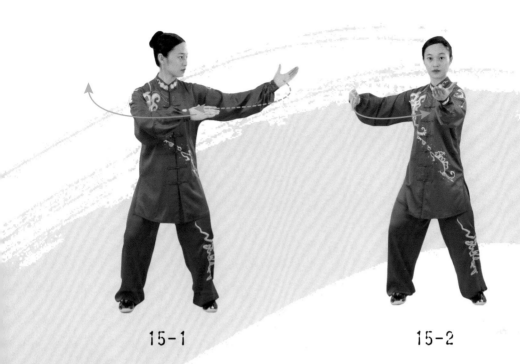

15-1 15-2

 第十五式:右捌勢

[動作]:身體右轉,兩拳變掌,向右橫捌,右掌心向外,左掌心向上,目視前方。

[要點]:捌勢意在以腰帶臂,橫向用力。

15.Right split

[Action]: Turn body right; fists become palms; rotate laterally rightwards, right palm outward, left palm upward; look forwards.

[Key Points]: The splitting force is expressed by exerting force laterally, the waist leads the arms.

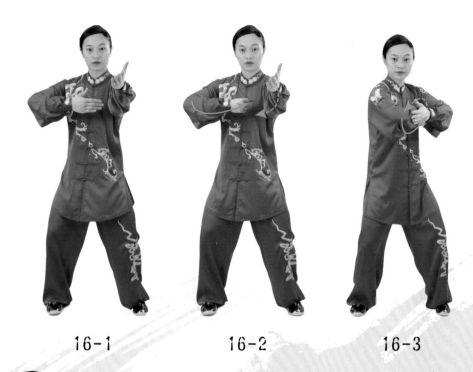

16-1　　　　16-2　　　　16-3

第十六式:右肘勢

[動作]:身體左轉,右掌變拳,拳眼向上,屈臂向前以肘擊打,左手附於右臂外側,目視前方。

[要點]:肘勢意在以肘尖為力點攻擊,先屈臂再發力。

16.Right elbow-strike

[Action]: Turn body right; right palm becomes fist; fist upright, bend arm and strike forward with elbow; place left hand to the outside of right arm; look forwards.

[Key Points]: The elbow-strike force is expressed through the tip of the elbow, first bending the arm and then releasing energy.

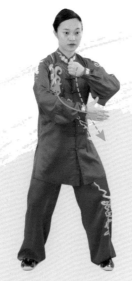
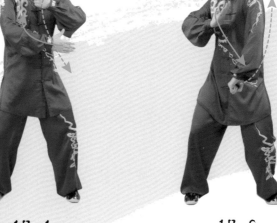

17-1 17-2

 第十七式:左靠勢

[動作]:身體右轉，左掌變拳，右拳變掌，兩臂環繞，
左臂撐圓，拳眼向內，用左肩臂向前靠擊，右掌收
至左肩旁，掌心向外，目視前方。

[要點]:靠勢意在以肩臂為力點，利用整個身體前移撞擊。

17.Left shoulder-strike

[Action]: Turn body right; left palm becomes fist, right fist becomes palm;
cycle the two arms; arch and brace left arm, fist downwards and lateral;
butt forwards with left shoulder and arm; bring right palm to left shoulder,
palm facing outward; look forwards.

[Key Points]: The shoulder-strike force is expressed with
the impact of the entire body through the shoulder and arm.

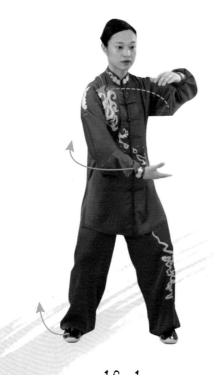

18-1

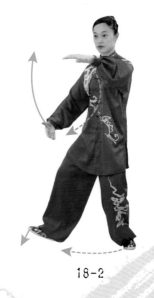

18-2

第十八式:進步左右掤勢

[動作]:左拳變掌，兩掌相抱，左掌在上，身體右轉，右腳尖外擺，兩掌翻轉相抱，右掌在上，收左腳向前上步成弓步，同時左臂向前掤出，右手下按至右胯旁；重心後移，左腳尖外擺，收右腳抱掌，左掌在上，右腳上步成弓步，同時右臂向前掤出，左手下按至左胯旁，目視前方。

[要點]:移動重心要平穩、緩慢，上下肢要協調一致。

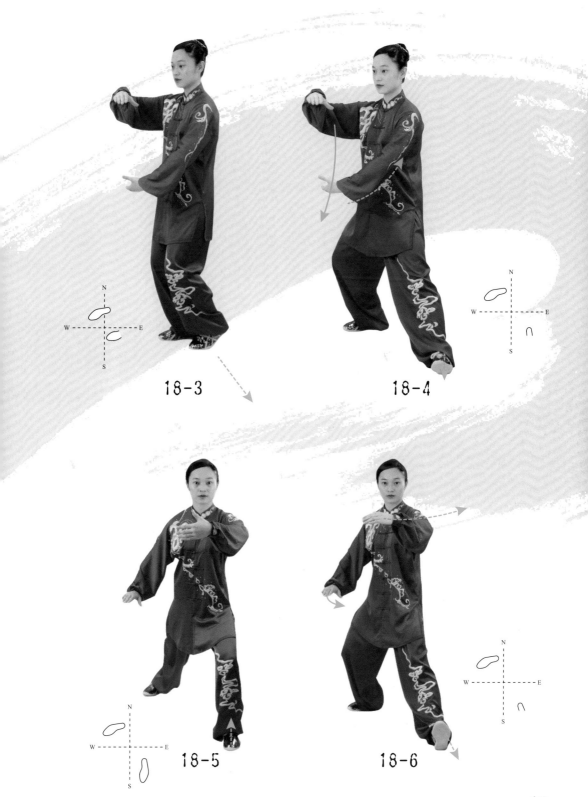

18-3

18-4

18-5

18-6

46

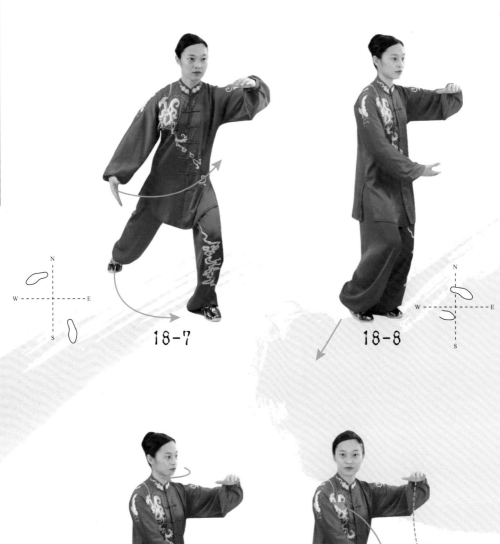

18-7

18-8

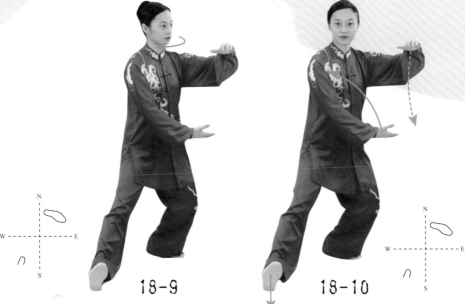

18-9

18-10

47

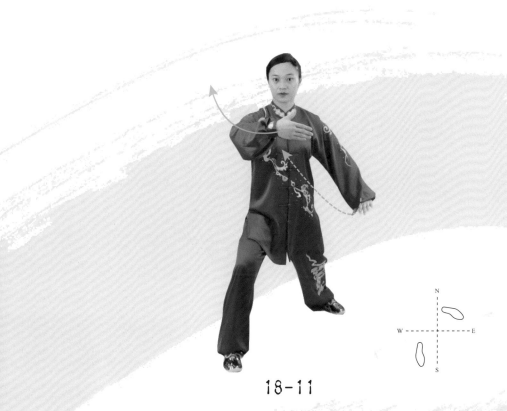

18-11

18. Advance left and right ward-off

[Action]: Left fist becomes palm; the two palms embrace as if holding a ball, left palm on top; turn body right, swing right toes outwards, two palms flip over and embrace again, right palm on top; take left foot forward into bow step, at the same time lift left arm forwards and outwards, press right hand down to the right hip; shift centre of gravity backwards, swing left toes outwards; draw in right foot, the two palms embrace, left palm on top; take right foot forward into bow step, at the same time lift right arm forwards and outwards, press left hand down to the left hip; look forwards.

[Key Points]: Shifting of the centre of gravity should be smooth and slow, and the upper and lower limbs should be co-ordinated in harmony.

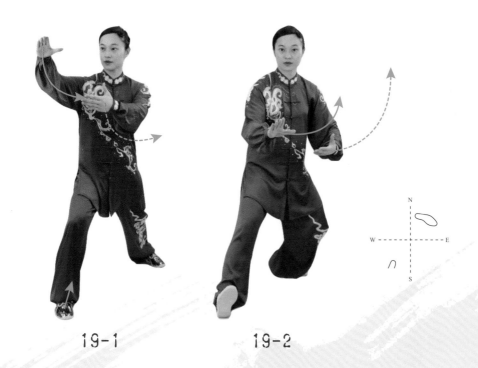

19-1　　　　　19-2

 # 第十九式:退步左右捋勢

[動作]:兩臂向前伸展,右掌心向下,左
掌心向上,重心後移,右腳尖翹起,身體
左轉,兩掌向左、向下捋帶,提右腳向後
撤步,兩臂翻轉,兩掌向右、向下捋帶,
目視右側。

[要點]:撤步位置不要在一條直線上,
兩臂捋帶要以腰為軸。

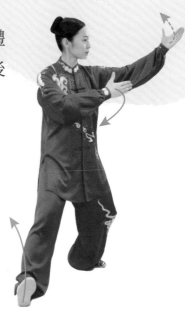

19-3

19-4

19-5

19-6

19.Withdraw left and right rollback

[Action]: Stretch arms forward, right palm down, left palm up; shift centre of gravity backwards, tip up right toes; turn body left, draw both palms to the left and downwards; lift right foot and step backwards; two arms flip over, draw both palms to the right and downwards; look rightwards.

[Key Points]: The withdrawal should not be in a straight line, and the arms should pull around the axis of the waist.

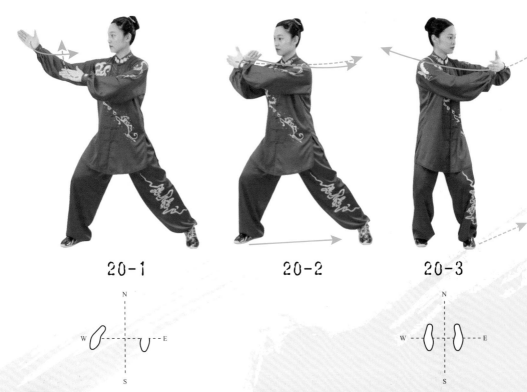

20-1　　　　20-2　　　　20-3

第二十式：左移步左擠勢

[動作]：左腳向左側開步,腳掌著地,兩掌相搭,左掌在外,
右腳跟步,兩掌經胸前向左側發力擠出,目視左側。

[要點]：發力前要蓄勁,以腰帶動,跟步與擠出要同時發勁。

20.Left-stepping left push

[Action]: Left foot sidestep to the left, landing with the sole; place palms together, the left palm outermost; right heel step, push both palms leftwards across the front of the chest, exerting force; look leftwards.

[Key Points]: Before exerting force, gather energy, drive with the waist, then step and push with the palms at the same time, releasing energy.

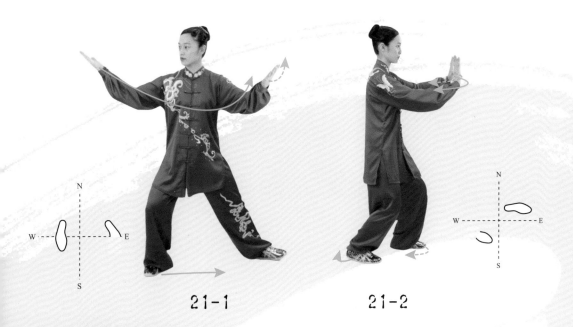

21-1 21-2

☯ 第二十一式:左移步雙按勢

[動作]: 左腳向左開步, 腳跟著地, 身體右轉, 同時兩掌
展開, 右腳跟半步, 兩掌經右肩向前推按, 肩高肩寬,
力達掌根, 目視前方。

[要點]: 左腳上步和兩掌展開要協調一致, 右腳跟步和兩
掌向前推按也要協調一致。

21.Left-stepping double hand press

[Action]: Left foot step to the left, landing with the heel; turn body right, at the same time open out the palms; right heel half step, two palms together push forward through the right shoulder, shoulder height and shoulder width; push through the base of the palms; look forwards.

[Key Points]: The left foot step and opening out the palms should be co-ordinated in harmony, and likewise the right heel step and forward push of the two palms should also be co-ordinated in harmony.

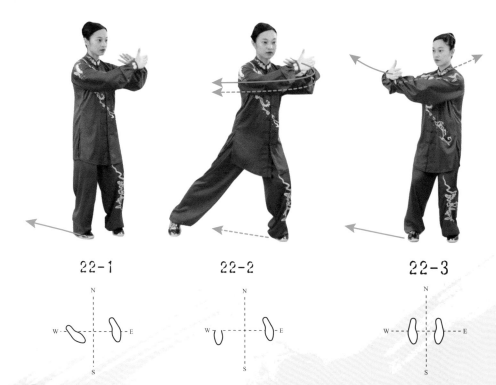

22-1　　　　　22-2　　　　　22-3

第二十二式：右移步右擠勢

[動作]: 左腳內扣, 右腳向右開步, 腳掌著地, 兩掌相搭, 右掌在外, 身體右轉, 左腳跟步, 兩掌經胸前向右側發力擠出, 目視右側。

[要點]:發力前要蓄勁, 以腰帶動, 跟步與擠出要同時發勁。

22.Right-stepping right push

[Action]: Left foot turn inwards; right foot step to the right, landing with the sole; place palms together, the right palm outermost; turn body right; left heel step, push both palms rightwards across the front of the chest, exerting force; look rightwards.

[Key Points]: Before exerting force, gather energy, drive with the waist, then step and push with the palms at the same time, releasing energy.

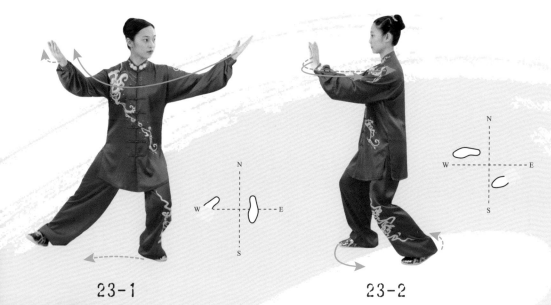

23-1 23-2

☯ 第二十三式:右移步雙按勢

[動作]: 右腳向右開步,腳跟著地,身體左轉,同時兩掌展開,左腳跟半步,兩掌相合經左肩向前推按,肩高肩寬,力達掌根,目視前方。

[要點]: 右腳上步和兩掌展開要協調一致,左腳跟步和兩掌向前推按也要協調一致。

23.Right-stepping double hand press

[Action]: Right foot step to the right, landing with the heel; turn body left, at the same time open out the palms; left heel half step, two palms together push forward through the left shoulder, shoulder height and shoulder width; push through the base of the palms; look forwards.

[Key Points]: The right foot step and opening out the palms should be co-ordinated in harmony, and likewise the left heel step and forward push of the two palms should also be co-ordinated in harmony.

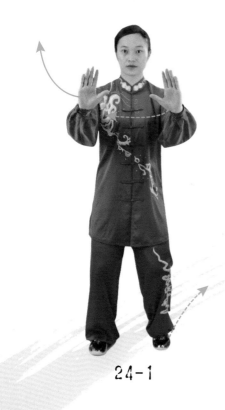

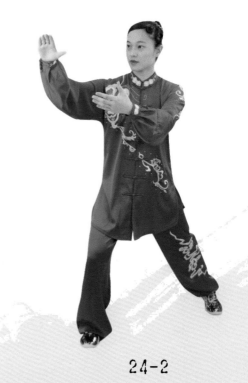

24-1

24-2

 # 第二十四式:退步左右採勢

[動作]: 身體左轉,右腳內扣,左腳向後撤步,兩掌變拳,隨重心後移向左、向下採拉,右拳心向上,左拳心向下,右腳尖翹起,提右腳向後撤步,兩臂翻轉,兩拳向右、向下採拉,目視右下方。

[要點]: 重心後移與兩手採拉要協調一致,提腳時保持中正穩定。

55

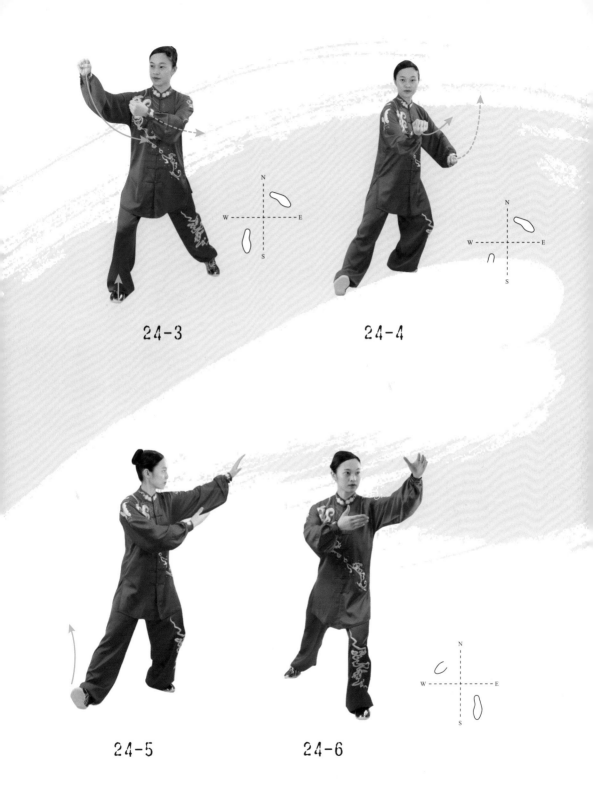

24-3

24-4

24-5

24-6

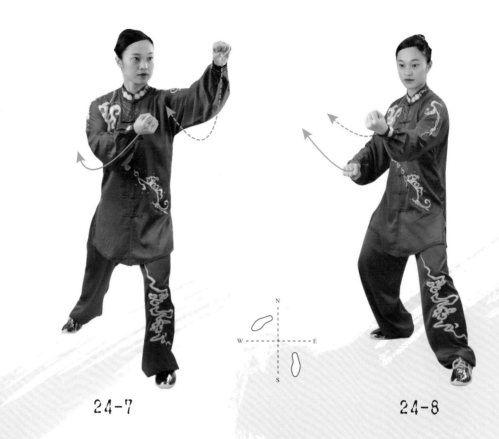

24-7

24-8

24. Withdraw left and right grab

[Action]: Turn body left, turn right foot inwards; left foot step backward, palms become fists; shift centre of gravity backwards and pull to the left and downwards, right fist fingers up, left fist fingers down, tip up right toe; right foot step backward, two arms flip over, two fists pull to the right and downwards; look towards the lower right.

[Key Points]: Shifting the center of gravity and pulling with both hands should be co-ordinated in harmony. When lifting the foot, maintain core stability.

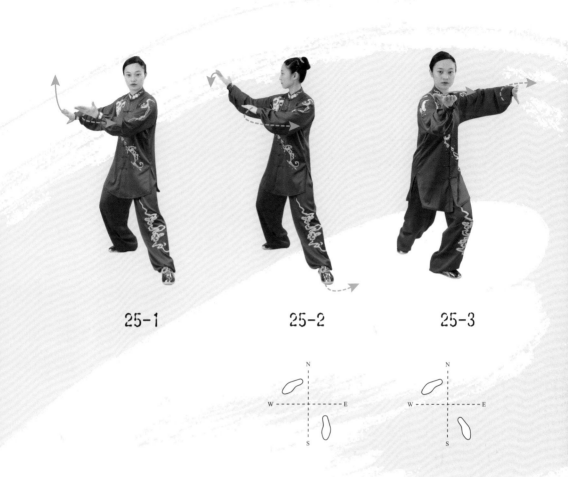

25-1 25-2 25-3

 # 第二十五式:進步左右捯勢

[動作]:左腳擺步,身體左轉,兩拳變掌,向左橫捯,右掌心向上,左掌心向外;右腳上步外擺,身體右轉,兩臂翻轉,向右橫捯,右掌心向外,左掌心向上,目視前方。

[要點]:左右擺步時分清虛實,重心移動要平穩,捯勁要以腰帶動。

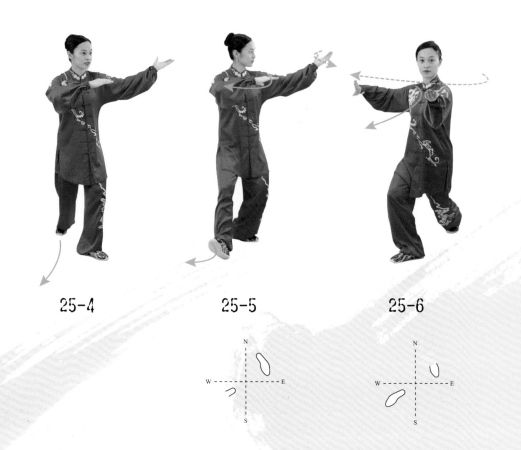

25-4 25-5 25-6

25.Advance left and right split

[Action]: Left foot rotating outwards, turn body left; fists become palms; rotate laterally leftwards, right palm upward, left palm outward; right foot step forward and rotating outwards, turn body right; two arms flip over; rotate laterally rightwards, left palm upward, right palm outward; look forwards.

[Key Points]: When the feet rotate outwards, the center of gravity should be move from one foot to the other foot clearly and smoothly, and the rotational energy should be driven by the waist.

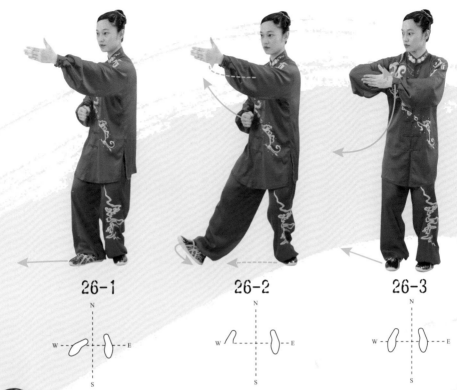

26-1 26-2 26-3

 第二十六式:右移步右肘勢

[動作]:左腳收至右腳內側,右腳向右側上步,右掌變拳收至右腰側,右腳尖內扣,左腳跟步,同時右手屈臂向右側以肘擊打,左手附於右臂外側,目視右肘方向。

[要點]:步法清晰,跟步與肘擊發力要協調一致。

26.Right-stepping right elbow-strike

[Action]: Bring the left foot alongside the right foot; right foot step to the right; right palm becomes fist close beside the right waist; Right toe turn inwards, left heel step, at the same time, bend the right arm to the right side and strike with the elbow; place left hand to the outside of right arm; look in the direction of the right elbow.

[Key Points]: Clear footwork, heel step and elbow-strike force should be co-ordinated in harmony.

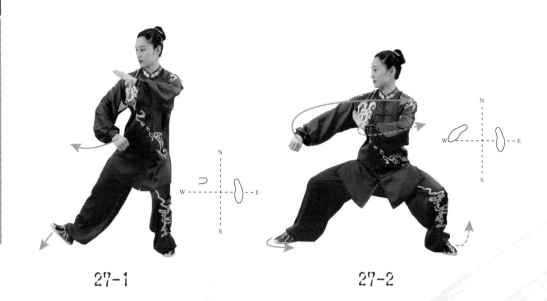

27-1 27-2

☯ 第二十七式：右移步右靠勢

[動作]：右腳向右開步, 腳尖向右, 成半馬步, 右臂撐圓, 拳眼向內, 用右肩臂向前靠擊, 左掌收至右肩旁, 掌心向外, 目視右前方。

[要點]：註意半馬步兩腳夾角成90°, 重心偏左腿。

27.Right-stepping right shoulder-strike

[Action]: Right foot step to the right, toes turn to the right, in a half horse step; arch and brace right arm, fist downwards and lateral; butt forwards with right shoulder and arm; bring left palm to right shoulder, palm facing outward; look forwards to the right.

[Key Points]: Pay attention in the half horse step that the angle between the feet is 90 degrees and the center of gravity is on the left leg.

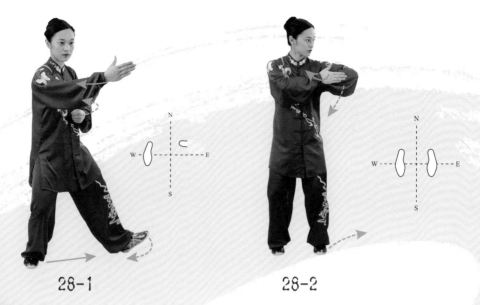

28-1 28-2

 第二十八式:左移步左肘勢

[動作]:右腳內扣,身體左轉,左腳腳尖先翹起後內扣,左掌變拳收至左腰側,右拳變掌在胸前伸展,左腳尖內扣,右腳跟步,同時左手屈臂向左側以肘擊打,右手附於左臂外側,目視左肘方向。

[要點]:步法清晰,跟步與肘擊發力要協調一致。

28.Left-stepping left elbow-strike

[Action]: Right foot turn inwards, turn body left, left foot first tips up and then turns inwards; left palm becomes fist close beside the left waist; right hand becomes palm across the chest;left toe turn inwards, right heel step, at the same time, bend the left arm to the left side and strike with the elbow; place right hand to the outside of left arm; look in the direction of the left elbow.

[Key Points]: Clear footwork, heel step and elbow-strike force should be co-ordinated in harmony.

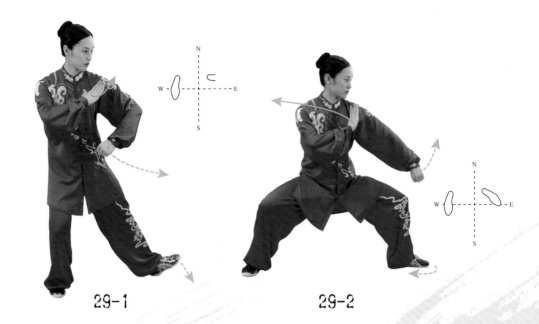

29-1 29-2

 第二十九式:左移步左靠勢

[動作]:左腳向左開步,腳尖向左,成半馬步,左臂撐圓,拳眼向內,用左肩臂向前靠擊,右掌收至左肩旁,掌心向外,目視左前方。

[要點]:註意半馬步兩腳夾角成90°,重心偏右腿。

29.Left-stepping left shoulder-strike

[Action]: Left foot step to the left, toes turn to the left, in a half horse step; arch and brace left arm, fist downwards and lateral; butt forwards with left shoulder and arm; bring right palm to left shoulder, palm facing outward; look forwards to the left.

[Key Points]: Pay attention in the half horse step that the angle between the feet is 90 degrees and the center of gravity is on the right leg.

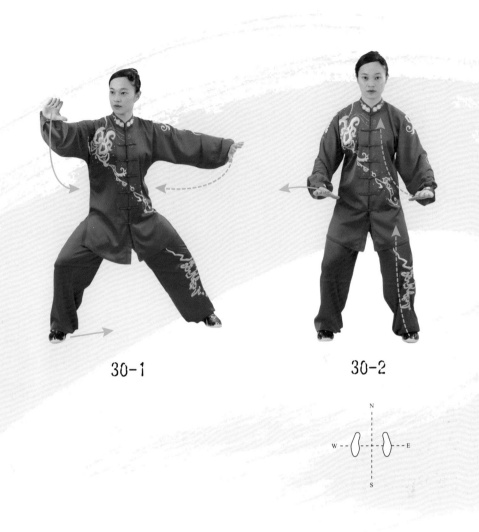

30-1 30-2

 # 第三十式:中定左右獨立勢

[動作]:左腳尖內扣,左拳變掌,兩掌分開,右腳收回半步,腳尖稍外擺,提左膝成獨立勢,同時左掌向上挑掌,右掌按至右胯旁;左腳下落至右腳內側,腳尖稍外擺,提右膝成獨立勢,同時右掌向上挑掌,左掌按至左胯旁,目視前方。

[要點]: 獨立步要中正平穩,提膝高過水平,上挑掌和下按掌形成對拉平衡。

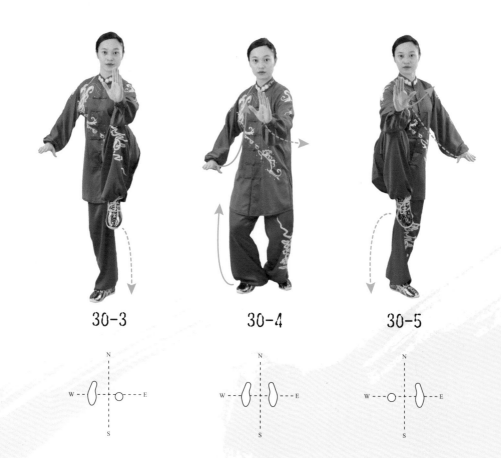

30-3 30-4 30-5

30.Central equilibrium standing on one leg both left and right

[Action]: Left toe turn inwards, Change palm of left fist, two palm are apart, Draw in the right foot half a step, toes turn slightly outwards; lift left knee while balancing on right leg, at the same time raise left palm and press right palm to the right hip; drop the left foot alongside the right foot, the toes turn slightly outwards; lift right knee while balancing on left leg, at the same time raise right palm and press left palm to the left hip; look forwards.

[Key Points]: Maintain balance while standing on one leg; lift knee above level, upper rising palm and lower pressing palm are in tension with each other.

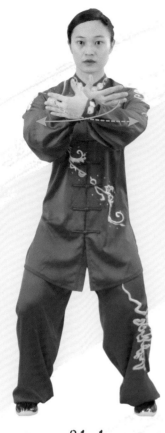

 第三十一式:十字手

[動作]:右腳下落, 左腳內扣, 兩腳肩寬平行, 兩臂相合於胸前, 左掌在外, 兩掌掌心均向內, 目視前方。

[要點]:兩臂有外撐之勁, 屈膝鬆垮, 沈肩墜肘。

31-1

31.Cross hands

[Action]: Drop the right foot, turn the left foot inwards, the two feet parallel shoulder width apart; the arms are crossed in front of the chest, the left palm outermost, both palms inward; look forwards.

[Key Points]: Both arms have the strength of external support. Knees bent, hips relaxed, shoulders sunk, elbows dropped.

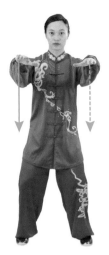 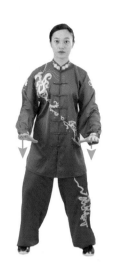 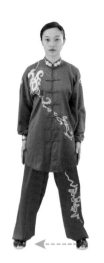

| 32-1 | 32-2 | 32-3 | 32-4 |

 ## 第三十二式:收勢

[動作]: 兩臂翻轉, 平抹分開, 掌心向下, 緩緩下落收至大腿兩側, 同時身體慢慢直立, 左腳收至右腳內側, 目視前方。

[要點]:收勢和起勢有所不同, 意識內斂, 周身放松。

32.Finishing form

[Action]: Turn arms over, spread them apart, palms down, slowly drop the arms to sides of the thighs, while raising the body upright; bring the left foot beside the right foot; look forwards.

[Key Points]: The finishing form is different from the starting form. The consciousness is directed inwards and the whole body is relaxed.

淘寶天貓店

購書掃碼

微信小程序

購書掃碼

【專賣店】

【武術/表演/比賽/專業太極鞋】

打開淘寶天貓
掃碼進店

微信掃一掃
進入小程序購買

正紅色【升級款】
XF001 正紅

藍色【升級款】
XF001　橘紅

黃色【升級款】
XF001　黃

紫色【升級款】
XF001　紫

粉色【升級款】
XF001　粉

黑色【升級款】
XF001　黑

綠色【升級款】
XF001　綠

桔紅色【升級款】
XF001 桔紅

銀灰色【經典款】
XF8008-2 銀灰

藍色【經典款】
XF8008-2 藍

黃色【經典款】
XF8008-2 黃色

紫色【經典款】
XF8008-2 紫色

正紅色【經典款】
XF8008-2 正紅

黑色【經典款】
XF8008-2 黑

綠色【經典款】
XF8008-2 綠

桔紅色【經典款】
XF8008-2 桔紅

粉色【經典款】
XF8008-2 粉

【太極羊 · 專業太極鞋】

多種款式選擇 · 男女同款

打開淘寶天猫
掃碼進店

XF2008B（太極圖）白

XF2008B（太極圖）黑

XF2008-1 白

XF2008-2 白

XF2008-2 黑

XF2008-1 黑

XF2008-3 黑

XF2008B（無圖）黑

XF2008B（無圖）白

XF2008-3 白

XF2008B-1 黑

XF2008B-2 黑

XF2008B-1 白

XF2008B-2 白

5634 白

【太極羊 · 專業武術鞋】

兒童款 · 超纖皮

打開淘寶APP
掃碼進店

XF808-1 銀

XF808-1 白

XF808-1 紅

XF808-1 金

XF808-1 藍

XF808-1 黑

XF808-1 粉

短袖款

长袖款

微信掃一掃
進入小程序購買

【高端休閑太極鞋】

兩種顏色選擇・男女同款

軍綠色

深藍色

打開淘寶天貓APP

掃碼進店

微信掃一掃

進入小程序購買

【學校學生鞋】

多種款式選擇 · 男女同款

可定制logo

可定制logo

女款 · 學生鞋

檢測報告

商品注冊證

男女同款 · 學生鞋

打開淘寶天貓APP

掃碼進店

微信掃一掃

進入小程序購買

【太極羊・專業太極服】

多種顏色選擇・男女同款

打開淘寶APP
掃碼進店

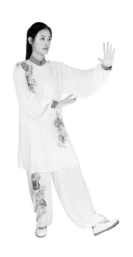

白色牡丹花

真絲綢黑白漸變

玫紅色三花扣雪紡

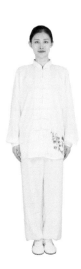

白色星光麻

亞麻

玫紅邊牡丹花

彩繪荷花

紫色麻紗

【專業太極服】

多種款式選擇・男女同款

微信掃一掃

進入小程序購買

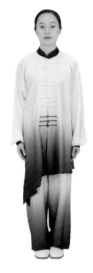

黑白漸變仿綢

淺棕色牛奶絲

白色星光麻

亞麻淺粉中袖

白色星光麻

真絲綢藍白漸變

【武術服、太極服】

多種顏色選擇・男女同款

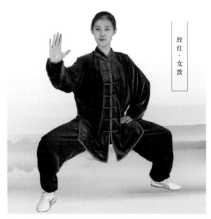

玫紅・女款

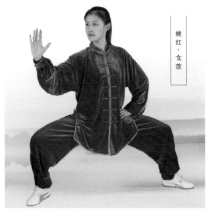

桃紅・女款

【專業太極刀劍】

晨練/武術/表演/太極劍

打開淘寶天猫
掃碼進店

手工純銅太極劍　　神武合金太極劍　　桃木太極劍　　平板護手太極劍　　手工銅錢太極劍　　鏤空太極劍

手工純銅太極劍　　神武合金太極劍

劍袋‧多種顏色、尺寸選擇

銀色八卦圖伸縮劍　　銀色花環圖伸縮劍

龍泉寶刀

棕色八卦圖伸縮劍　　紅棕色八卦圖伸縮劍

微信掃一掃
進入小程序購買

【太極扇】

武術/廣場舞/表演扇

可訂制LOGO

紅色牡丹

粉色牡丹

黃色牡丹

紫色牡丹

黑色牡丹

藍色牡丹

綠色牡丹

黑色龍鳳

紅色武字

黑色武字

紅色龍鳳

金色龍鳳

純紅色

紅色冷字

紅色功夫扇

紅色太極

打開淘寶天猫APP

掃碼進店

微信掃一掃

進入小程序購買

【正版教學光盤】

正版教學光盤 太極名師 冷先鋒 DVD包郵

香港國際武術總會裁判員、教練員培訓班 常年舉辦培訓

　　香港國際武術總會培訓中心是經過香港政府注册、香港國際武術總會認證的培訓部門。爲傳承中華傳統文化、促進武術運動的開展，加强裁判員、教練員隊伍建設，提高武術裁判員、教練員綜合水平，以進一步規範科學訓練爲目的，選拔、培養更多的作風硬、業務精、技術好的裁判員、教練員團隊。特開展常年培訓，報名人數每達到一定數量，即舉辦培訓班。

報名條件：熱愛武術運動，思想作風正派，敬業精神强，有較高的職業道德，男女不限。

培訓內容：1.規則培訓；2.裁判法；3.技術培訓。考核內容：1.理論、規則考試；2.技術考核；3.實際操作和實踐(安排實際比賽實習)。經考核合格者頒發結業證書。培訓考核優秀者，將會錄入香港國際武術總會人才庫，有機會代表參加重大武術比賽，并提供宣傳、推廣平臺。

聯系方式

深圳：13143449091(微信同號)
　　　13352912626(微信同號)
香港：0085298500233(微信同號)

國際武術教練證

國際武術裁判證

微信掃一掃

進入小程序

香港國際武術總會第三期裁判、教練培訓班

打開淘寶AP

掃碼進店

【出版各種書籍】

申請書號>設計排版>印刷出品
>市場推廣
港澳台各大書店銷售

冷先鋒

國際武術大講堂系列教程之一
《如何練好太極八法五步》
香港先鋒國際集團　審定
太極羊集團　赞助
香港國際武術總會　出版
香港聯合書刊物流有限公司發行

國際武術大講堂系列教程之一
《如何練好太極八法五步》

代 理 商：台灣白象文化事業有限公司

書　　　號：ISBN 978-988-74212-2-1

香港地址：香港九龍彌敦道525-543號寶寧大廈C座412室

電　　　話：00852-95889723 91267932

深圳地址：深圳市羅湖區紅嶺中路1048號東方商業廣場一樓、三樓

電　　　話：0755-25950376 13352912626

台灣地址：401 台中市東區和平街228巷44號

電　　　話：04-22208589

印　　　刷：深圳市先鋒印刷有限公司

印　　　次：2020年5月 第一次印刷

印　　　數：5000冊

總 編 輯：冷先鋒

責任編輯：鄧敏佳

責任印製：冷修寧

版面設計：李文傑

圖片攝影：李文傑 陳璐

網　　　站：www.taijixf.com

郵　　　箱：lengxianfeng@yahoo.com.hk